# How To Solve every problem YOU MEET

THE GOLDEN SECRET FOR LIVING

Copyright@ 2019 By Poto Stephen

ALL RIGHT RESERVED

No part of this book may be reproduce or copied in any form or any means, graphical, electronical or mechanical including photocopying recording typing or information retrieval systems without the written permission of the writer.

**DEDICATION**

This book is dedicated to God Almighty who gave me the inspiration to bless mankind

## ACKNOWLEDGEMENT
4

I want to sincerely from the depth of my heart, appreciate Dr. David Oyedepo for his materials at my disposal, my mentor Pastor Chris Oyakhilome, pst Emmanuel Ikure, Pst David O. Buoye and my lovely family and friend who stood by me.

The wise saying

Wisdom is the freedom to your kingdom

The scripture is the picture to you future

Faith is the catalyst that bring your destiny to reality at once.

## CONTENT

1. The starting point of life — 9
2. The power of inspiration — 13
3. What is problem — 22
4. Visualize your goal — 27
5. Understanding the place of information — 31
6. How to open your mind — 35
7. The two major reason for failure — 40
8. Focus on your potential not your failure — 45

| | | |
|---|---|---|
| 9. | Time killers | 50 |
| 10. | How to solve every problem you meet | 54 |
| 11. | The wisdom of the wise | 60 |
| 12. | The power in you | 63 |
| 13. | The golden secret for living | 66 |
| 14. | Take action now | 72 |
| 15. | The wise saying. | 7 |

## INTRODUCTION

The beauty of life lies in the happiness of mankind, but its takes understanding to enjoy ones destiny.

As a child, I never consider anything impossible because I see possibility in everything.

Possibility is the solution to man's advancement and also the key to his golden secret for living. This is a wonderful time to be living with joy unspeakable. There has never been a creating world like this since history.

Everything is moving faster, children are turning to adult and adult are turning to grand pa and grand ma. Age is telling on people; wariness has become the order of living.

What a pain to the heart to die unfulfilled without solving problem around you.

Solving people problem is the greatest joy as life is concerned. It is the best legacy you can live on this earth.

Possibility still remained the key to solve any problem as far as I am concerned.

Friend, what some people called problem are not really problem but they have allow weed to grow in their mind. The mind is the power house of everyman. It is also the brain backing everything we are experience today.

Friends, when I was growing up, I now understood that the word impossible is the beginning of my problem.

The kind of information you allow into your mind, will either build you or destroy you.

I am a kind of person, I hate failure, I never wanted to fail in life. I did everything possible, I wanted to settle in life at 30yrs but getting to 30yrs, things started looking impossible.

Friend, the very day I understood that I am a man and I have to take responsibility and become responsible, life turned back at me.

Thank God, I started thinking the more as a writer which later lead to the writing of this book, how to solve every problem you meet. The golden secret for living.

Friend, there is no problem anywhere, man's problem lies in his brain, the quality of your thinking will determined the outcome of your solution to problem.

The only problem man's has is ignorance and I will throw more light on it in chapter three.

You are welcome to a world of solution.

## CHAPTER 1

Every step you take now either takes you forward or bring you backward. One of the greatest mishaps that can ever happen to any man is to lack an idea of where he is going and how to get there.

The starting point of life is the road called forward in life.it is the beginning of every destiny. If it is not properly guided or protected it's can be destroy.

There is a way which seemeth right unto a man, but the end there of are the way of death.
## Proverbs 14:12

The starting point of life really matter a lot because in every journey of life, if you miss the first step, it can be very dangerous.

The starting point of life is your life and you are not to play with it. Your life begins with it.

Your height of exploits is a function of your personal input. No contribution, no accomplishment! "life is a product of personal adventure"

**Dr. David Oyedepo**

At the starting point of life, you will know that life has just began and you must take the bull by the horn.

The starting point of life is the point where you take decision on your own and if not wisely taken you face the music.

Friend, for you to take any decision, you need knowledge and knowledge is the giant's secret card. Insufficient knowledge is the reason for weak decision.

If your decision is poor, your outcome will be poor, decision is the gear lever of destiny that decides its motion.

The starting point of life is the point where we ask the creator about our destiny and how to walk toward it.

God is the maker of heaven and earth. He is the owner of the soul, asking God about your destiny and how to go about it is the wisest thing you has make.

For my thoughts are not your thoughts, neither are your ways my ways, saith the Lord.
### Isaiah 55:8

Before I formed thee in the belly I know thee, and before thou comest forth out of the womb I sanctified thee, and I ordained thee a prophet unto the nation.
### Jeremiah 1:5

Walking in divine plan transforms an ordinary man to an extraordinary man.

Friend, the cheapest way out of frustration is to abide in God's plan for your life. There is no short-cut to excellence in life.

Friend, if failure is in your heart in your starting point, know that you will surely fail but if success is in your heart in your starting point, you will succeed if you work toward it.

An individual's highest fulfilment, greatest happiness and widest usefulness are to be found in living in harmony with his will.
> **John D. Rockefeller JC**

Friend, life does not begin in the womb, it starts with God. "one without a definite purpose in life can never be useful or happy.

The secret of success is constancy in purpose.
**Benjamin Distael**

"For there is no road to success, but through a clear strong purpose".

<div style="text-align:right">T.T Munger.</div>

## CHAPTER 2

## THE POWER OF INSPIRATION

Inspiration is the master key to super natural intelligence and the cure for all man's problem.

But there is a spirit in man and the inspiration of the Almighty giveth them understanding.
**Job 32:8**

You need inspiration in order to understand something you do not know.

The highest order of mental excellence is accessible by inspiration. Without inspiration, there is no genius inspiration is the unction of God

or the spirit of God in motion that comes upon you in order to do something above the natural.

Inspiration, not mental exertion, is the master-key to a world of supernatural intelligence because what is from above is above all.

Inspiration is what is backing everything we are enjoying today. Without inspiration there is no development which will lead to mediocrity.

I see true inspiration as the creative tool for man's guide.

All scripture is given by inspiration of God, and is profitable for doctrine, for reproof, for correction, for instruction in righteousness.
**2 Timothy 3:16**

Daniel is a man of inspiration that is why the king Nebuchadnesar called him Holy Gods and worshipped him.

Every great man and woman in the bible and in our present world is been rule by the inspiration of God that is the spirit of God working in them.

Inspiration has nothing to do with a man's age. No wonder Elihu said.

I said, days should speak, and multitude of years should teach wisdom.

But there is a spirit in man: and the inspiration of the Almighty giveth them understanding.

Great men are not always wise: neither do the aged understand judgment.

**Job 32: 7-9**

Friend, mental intelligence can only become a reality via the instrument of inspiration. Inspiration is what has be keeping man going.

The power of inspiration cannot be compared with all form of academic excellent you have. Inspiration is the covenant catalyst that makes the reaction take place at all.

As a writer, I so much believe on inspiration because that is the secret behind my living and my success.

When inspiration comes on me, I do above my mental strength and I see result coming to me at ease.

The movement of the spirit within your mental region is what generates supernatural intelligence.

## THE ENEMIES OF INSPIRATION

The enemies of inspiration are many but I will just talk on few.

Enemy are the things that do not want you to succeed but bring you down to nothing. This enemies weight down your spirit, causing it to choke under their weight.

They paralyze your mental abilities, because the devil know that he cant handle you when you are inspired.

So he generates concerns, anxieties and burdens to keep you too busy to open up to God's inspiration. When you as a person do no longer have inspiration know that you are finished.

1. Fear
2. Fun
3. Devil

## FEAR

In the atmosphere of fear, inspiration die because there is no proper focus and when you lost your focus, you have lost your force of reasoning.

Fear is a great enemy of inspiration, fear make one to loss his or her strength and losing your strength is losing your mental sense of reasoning. When you are not balance in your inside no way for inspiration to come in.

Friend, work on your mind in order to overcome this enemy of inspiration called fear.

## FUN

A life of fun is a life of wastage, when fun dominate your mind, inspiration will be very far from you. And you know inspiration is the key to life. You can't be drinking, misbehaving and expect inspiration to drop on you.

Every true inspiration is from God, run from fun and get inspiration to change your life. Fun is a real enemy of inspiration

## DEVIL

Nothing good comes from the devil, not all that glitter is good. Look above what you can see, where the devil is there is always short of inspiration, infact no true inspiration because light and darkness can never be friends or brothers.

The devil is the number one enemy of true inspiration. He dislike anything good to come to man. There is a way that seemeth right into a man, but the end thereof are the ways of death.
### Proverbs 16:25

People who operate by inspiration are people who command exploits.

God's wisdom is package in the Bible, which was delivered to man via the channel of inspiration, not intellectualism.

## HOW TO GET THIS INSPIRATION

1. Through meditation
2. Through singing
3. Through reading

## THROUGH MEDITATION

Meditation mean giving mental focus to issues of interest, and maximum focus always create maximum input.

When you subject knowledge to intense meditation, the end product in understanding.

Understanding comes through a conscious process of meditation.

Friend, you can generate inspiration through meditation.

But we all, with open face beholding as in a glass the glory of the Lord, are changed into the same image from glory to glory, even as by the spirit of the Lord.

**2 Corinthians 3:18**

The major secret of every great man, is constant meditation which in turn to inspiration and then grant the solution.

### THROUGH READING

Through reading, you get inspiration which you can use to trigger your potential because he that follow the wise will be wiser.

I read a book by Alfred Femi Martins "Being the best that changes my life. There are lot of inspiration in that book that can turn anyone who care to read over night to be a champion.

Great readers indeed are potential leaders of tomorrow. Reading is living and living is learning.

Many things we are enjoying today come through inspiration which some people cut through books.

## THROUGH SINGING

But now bring me a ministred. And it came to pass when the ministred played, that the hand of the Lord came upon him.

**2 Kings 3:15**

Good song trigger inspiration that can turn any one life for the better.

When you sing, what you are doing is working up the spirit of God inside you and something unique most drop in you which I called inspiration.

Inspiration is the bedrock for living and the gate to a triumphant life.

Friend, you can sing the spirit of God into manifestation to create your world.

## CHAPTER 3

## WHAT IS PROBLEM?

A problem mean any difficulty that has to be resolved or dealt with.

From the above meaning you can see that man do not really have a problem. Because anything that can be resolved or dealt with is not really a problem.

The problem of man lies in his mistake. Even as mistake may turn out to be the one thing necessary to a wonderful achievement.
**Henry Ford.**

The cause of a mistake is ignorance, where there is ignorance there is always a problem.

What some people called problem is not really a problem but laziness of heart in them. They are too lazy even to think straight and act straight.

The problem of man lies in his brain, which is the inability to use the brain properly or wisely.

Fools will always find themselves in the congregation of the death.

What can be resolved or dealt with is not really a problem. When God created everything, he says everything is good.

Laziness and ignorant has really spoil a lot of thing for mankind.

Until something is done, nothing will be done. Change for the better for things to change for you

Friend, every man problem is his ignorant, discover who you are in the creator book and see no problem for the rest of your life.

I will go before thee, and make the crooked places straight.

**Isaiah 45:2**

Who is he that saith, and it cometh to pass, when the Lord commandeth it not?

**Lamentation 3:37**

Thy word is a lamp unto my feet, and a light unto my path.

**Psalm 119:105**

And it shall came to pass, if thou shalt hearken diligently unto the voice of the Lord thy God, to observe and to do all his commandments which I command thee this day, that the Lord thy God will set thee on high above all nations of the earth.

**Deut 28:1**

Friend, come out of darkness, there are no mountain anywhere, change your thinking and see the light of solution to every of your so called problem.

All scripture is given by inspiration of God, and is profitable for doctrine, for reproof, for correction, for instruction in righteousness.

**2 Timothy 3:16**

Take fast hold of instruction, let her not go: keep her, for she is thy life.

**Proverbs 4:13**

Therefore whosoever heareth these sayings of mine, and doeth them, I will like him unto a wise

man, which built his house upon a rock.

**Matthew 7:24**

Pay the price, no risk no gain. The gain of life lies in paying the price for greatness. Iron sharpened iron, so a man sharpeneth the countenance of his friend.

**Proverbs 27:17**

Friends, you need fresh information in order to be fresh in life. Many people has allow little things to

become great burden to them which have resulted to old age at once.

There is no new thing that has not be happening before. Your case is not the different but your mentality has made your own different and difficult to handle.

Problem only comes to those who always think of problem. Because what you repeatedly fear you see.

Friend, if you think of a problem you must have one. Your weariness cannot add anything to a cubits but proper thinking result to proper solution.

Never belittle anyone, God can use anything or anyone to change your story.

## CHAPTER 4

## VISUALIZE YOUR GOAL

Success is goals and visualizing it is power. Clear goals increase your confidence and boost your levels of motivation.

Life without a goal is like a life without a vision and where there is no vision the people perish.

A dream without a goal is just a wish.
**Bill Cole**

Goals are the fuel that keep the vehicle of achievement moving, with goals, you can fly like the eagle.

Cherish your visions and your dreams as they are the children of your soul, the blueprints of your ultimate achievements.
**Napoleom Hill**

Visualization holds the key to life's success, until you visualize a thing, you can never have it.

"Lord, grant that I may always desire more than I can accomplish". **Michael Angelo**

Visualization is what brings creativity and creativity is what brings development.

Friend, you need to visualize your goal in order to succeed on this earth because fear will surely come your way but your goal will to keep you moving no matter the storm.

Until you start to visualize your goal in life, you have no value for living.

Never think about the past but think about the future.

Never live for today but live for tomorrow.
**Poto Stephen**

Friend, what you picture you capture in return. Visualize your goal mean to picture your future.

All improvement in your life begins with an improvement in your mental picture. Visualization activates the law of attraction.

Visualization activate your mind to do above your strength.

Wayne Dyer says, "You will see it when you believe it" Dennis waitley says that your mental images are "your previews of your life's coming attraction.

Albert Einstein said, "Imagination is more important than facts.

Napoleon Bonaparte said, "Imagination rules the world.

Napoleon Hill said, "Whatever the mind of man can conceive and believe, it can achieve"

Visualizing your goal helps you to think, act and persist

"Imagination governs the world".
**Benjamin Disracli**

"Imagination makes man the paragon of the animals" William Shakespeare

"Imagination is the beginning of creation. You imagine what you desire, you will what you imagine, and at last you create what you will".
**George Bernard Shaw**

Friend, you to feed your mind with the images of your by picturing it, speaking it and doing see the success you desire. Successful people are those who visualize the kind of success they want to enjoy in advance.

You choose what you want to be by visualizing it and act on it.

Friend, you need to mold and shape your thinking by always walking toward your goal in life.

The way to transform, improve, and upgrade your life is by renewing your mind.
**Chris Oyakhilome.**

The mind is an intangible, spiritual entity, and only God's word can give the best light on it.
**Chris Oyakhilome**

A journey of a thousand years begins with in single step.

**Confucious**

Friend, use your mind to capture your world by making a positive impact.

# CHAPTER 5

## UNDERSTANDING THE PLACE OF INFORMATION

Every exploit in life is a product of information. Information is the key secret for life and the power to become great.

The quality and the quantity of the information inside of you will determine your value in life.

Greatness is not all about title but all about what you have inside and bringing it to materialize by affecting your world positively.

You cannot be informed and not be transformed. It is information that breeds transformation.

Friend, it take information to be free from stagnation and deformation. Lack of information brings about deformation.

Information is the light that enlighten your destiny and the cure for all frustration.

The entrance of thy words giveth light, it giveth understanding unto the simple.
### **Psalm 119:130**

Your speed in life is determined by the quality of information at your disposal, and the level of insight with which you are operating.

Don't stop learning, keep moving, the examination of life do not have a timetable. Great learners are great potential leaders of the future.

You cannot go beyond the information at your disposal, the brighter you see, the faster you go. The more informal you are, the greater the results you command.

Friend, think straight and live straight, many people says, education is not the ultimate but money.

My people are destroy for lack of knowledge.
**Hosea 4:6a**

The bible do not say, my people are destroy for lack of money but lack of knowledge which is information.

Information is the bedrock for living and the juice for life. Without information, no one truly has a future. Information will reduce your religious struggles and build your mental excellent.

Nothing is more valuable than insight in the journey of life.

"You are either running with a vision, going on a mission, or burning with a passion. If you do not belong to any of these, life is reduced to a burden"

**Dr. David Oyedepo.**

Pay the price by running after relevant information.

"I don't think much of any man who is not wiser today than he was yesterday"

**Abraham Lincoln**

"Anyone who stops learning is old, either at twenty or eight. Anyone who keeps learning stay young. The greatest thing in life is to keep your mind young" henry Ford.

Friend, settle down for relevant information in order to become a star tomorrow.

The differences between the wise and the fool is their level of insight. Insight still remained the secret of every true champion.

Everything we are enjoying today is as a result of the information of yesterday.

Friend, you need relevant information for things to change in you for the better. Until something changes within you, nothing changes around you.

Every changes begins from within. Without a change within, there can never be a change without.

**Dr. David Oyedepo**

**CHAPTER 6**

**HOW TO OPEN YOUR MIND**

The mind is the capital of the body. It is the door to every opening in the body.

Keep thy heart with all diligence for out of it are the issue of life.

**Proverbs 4:23**

The mind as a man's seat of feelings or thoughts. It must be correctly use to product correct result. Many people are just opening their mind to everything either good or bad.

Friend, you are a person of great value, but your value is essentially a function of the use to which you put your mind.

The mind need to be protected from unwanted seed which will later become a problem to it.

Many people allow weeds to grow in their mind and the weeds later become a catalyst to destroy their body.

Your mind is the factor that makes you relevant to the world. When it is out of place, your place in life is lost.

Your worth in life is essentially a product of the use which you put your mind.

For to be carnally minded is death, but to be spirit usually minded is life and peace.

Because the carnal mind is enmity against God. For it is not subject to the law of God, neither indeed can be.

**Roman 8: 6-7**

Friend, managing your mind is the greatest asset in life because you need to know how to use your mind effectively.

One of the greatest problem of man is mind management which has really pull great destiny to the ground.

Who are you today is a function of your mind. You personality is the expression of the contents and working of your mind.

Managing your mind is the primary principle for increasing your value, multiplying your success, up-grading your state, and thus, enlarging your estate.

Friend, you are a reflection of your thoughts. Your life is the outward manifestation of the inner workings of your mind.

## THE FOLLOWING ARE WAYS OF HOW TO OPEN YOUR MIND

1. Focus it on the right thing
2. Listen to instruction
3. Meditate in the word of God
4. Follow good company

### FOCUS IT ON THE RIGHT THING

When you focus your mind on the right thing, you will continue to see well. One of the first things you must learn to do with your mind is to focus it on the right thing.

Friend, maximum focus creates maximum impact. A man will succeed at almost anything for which he has in wavering focus.

**LISTEN TO INSTRUCTION**

There is a way that seemeth right unto a man, but the end there of are the ways of death.
### Proverbs 16:25

But wisdom is profitable to direct.
### Ecclesiastes 10:10

Hear instruction, and be wise and refuse it not.
### Proverbs 8: 33

For the commandment is a lamp, and the law is light and reproofs of instruction are the way of life.

**Proverbs 6: 23**

I will instruct thee and teach thee in the way which thou shalt go. I will guide thee with mine eye.

**Psalm 32:8**

The word of God is God, meditating on the word is the best thing on this earth.

He sent his word and healed them, and delivered them from their destructions.

**Psalms 107:20**

Oh, how I love your law, it is my meditation all the day, you through your commandment, make me wiser than my enemies. **Psalm 119: 97-986**

### FOLLOW GOOD COMPANY

He that walketh with wise men shall be wise: but a companion of fools shall be destroyed.

**Proverbs 13: 20**

Be not deceived: evil communication corrupt good manners.     **1corinthians 15:33**

The wise shall inherit glory, but shame shall be the legacy of fools.     **Proverbs 3:35**

## CHAPTER 7

## THE TWO MAJOR REASON FOR FAILURE

For every happening there is always a reason and until the reason is known, it will continue to happen.

"The greatest tragedy in life is not death, but life without a reason, it is dangerous to be alive and not know why you were given life.

**Myles Munroe**

Failure is not an accident, it is cause by something if not properly handle, it's will repeated itself.

Man today is looking for short cut to make it in life but forget that life has its own principle.

**THE FOLLOWING ARE THE MAJOR REASON FOR FAILURE**

1. Fear
2. Ignorance

## **FEAR**

Fear stands for

F- False

E- Evident

A-Appearing

R-Real

Fear is the downfall of any great destiny, it is the weapon the devil use to diffuse the flow in the spirit

Fear is the real reason for so many death today, it's kill slowly and later finish the all body.

Fear deflates power, fear is a snare, and it brings men into bondage.

Friend, fear is a principle hurdle you must overcome before you can become a winner in life. Walking in fear mean walking in death because very soon the end product is death.

Until you understand that fear is a trick of the devil you will become a victims of it.

To overcome fear is to always be conscious of the fact the lord your God is with you always. Fear sometime lead to greed which in turn lead to war.

Some people in leadership position do steal because of fear of the future. Some will say, if a leave office today what will I do. So let me continue stealing till I leave power, so that me and my family will not suffer.

But for some, suffering become their portion because life is all about sowing and reaping which is a law for living.

## **IGNORANT**

My people are destroyed for lack of knowledge.
**Hosea 4: 6b**

My people are destroyed for lack of insight

My people are destroyed for lack of information

My people are destroyed for lack of learning

Friend, until you are inform, you will be deform.

Until you are inspired, you will be expired

Until you are transform, you can never be renewed

Ignorance is one of the major tool for madness used to sink great ideals, dreams, vision and destiny.

An ignorant person is a foolish person, because he does not know his right from his left. Infact he is a blind person and a blind person will always fall into the pit of destruction.

The greatest tragedy is for you to have eyes and you can't see. Ignorance has made many people to belittle themselves unknowing to them.

Friend, a blind mind is worse than a blind eyes. Your mind will die, expect you put it to work.

A person walking in ignorance will always say information is not the ultimate, so what is the ultimate.

The end of ignorance is bitter than worn wood and its ways are shame, disgrace and untimely death.

My son pay attention to my wisdom, lend your ear to my understanding.

**Proverbs 5:1**

Apply your heart to instruction, and your ears to words of knowledge.

**Proverbs 23:12**

## CHAPTER 8

## FOCUS ON YOUR POTENTIAL NOT YOUR FAILURE

One of the greatest challenges that most people face today is the failure of the past. It's has enslave great destiny.

The way you think of yourself form on image, on opinion, on impression in your mind about yourself Potential mean the greatness in you or the vision in you as a youth. Every great things we see today is in you, because you and I have a covenant

of greatness with God. No wonder the bible say: "but seek ye first the kingdom of God and His righteousness and all things shall be added unto you"

-Matt 6:33

Until you discover your potentials, you wouldn't have the vision to actualize your dream. The kingdom is right inside of you. The day you discover this light, it is that day you walk into your greatness.

Potential is not anywhere but it is within you, the seed of greatness is inside of a man, so is the responsibility of everyone to discover it.

Don't give up; don't lose hope one negative experience does not negate the word of God whatever you focus your attention upon you give strength and momentum to" John mason

Focus is the reason why some succeed and others fall. Maximum focus creates maximum impact. Broken focus is the real reason why men fail" men of broken focus end up with broken dreams. When

the mind is divided in the pursuit of any Endeavour failure is inevitable.

Failure means lack of success in doing things or ability to achieve plan. Many great men you see today where ones failure but they press on with their target and today the world are celebrating them.

There is a power within every individual capable of radically transforming his destiny. It is the power of a true decision "we make our decision

based on our fundamental beliefs and character qualities'"

ZIG ZIGLAR

"Your past decision have created your present circumstance, your present decision will create your next set of circumstances"

-ALFRED FEMI MARTINS

"You are the way you are because that's the way you want to be. If you really wanted to be any

differences, you would be in the process of changing right now"

-FRED SMITH

You life style is governed by your thinking some people live as if they have no choice due to past failure which have started robbing they of their greatness.

What do you think of yourself?

"For as he thinketh in his heart, so is he"
 -Proverb 23:7

Many scientists fail number of times in order for more researching on different experiment but today they are greatest scientist who have touch lives positively.

Example of this great scientist or men areNewton, Galileo

As youth don't be afraid of ventures, If a man harbor any sort of fear, thinking he or she is doing good, not knowing he is damaging his personalities and making himself a landlord of ghost.

Improvement is the largest room on earth. There is always room for improvement; there is no end to progress.

Commitment to improvement is launching yourself on the flight to distinction.

You owe yourself the best opportunity possible for expansion and expression but you need to focus on your potential not your failures.

Our whole existence thrives on improvement! It has brought us to where we are and it is the vehicle

taking the world to its next phase. To rest on your oas is to give room to the spirit of failure.

To everything there is a season. Your season of frustration and failure is about to give way to fruitfulness and success. Don't let your past punish your present and paralyze your future. You were created to do great things, to stand out not to blend in. the world will make room for you when you have something new to offer.

## CHAPTER 9

## TIME KILLERS

We all have 24hours in a day, time is in evocable. Time is the universal currency in the purchase of success.

Time is also the precious thing God has given to man. Anything that has wasted your time, has

wasted your life. It is impossible to separate success from the wise use of time.

Friend, until you invest your time wisely, you have no future, time is life itself. It must be respected.

What drives your time should be your goal in life not valueless things. What we do with our time today, will determine how our tomorrow will look like.

Time is moving, it is not static. A second, a minute, an hour, that has gone, can never be

retrieved again. Every person on this planet earth has 24hours each day but how we spend it really matter a lot. Managing your time properly is the greatest achieve one can have in life.

Our time must be value driven, because there are time killers.

**THE FOLLOWING ARE TIME KILLERS**

1. Procrastination
2. Excuses
3. Fun

## PROCRASTINATION

Procrastination is a thief of time, it is the tool that destroys great opportunity and time.

Procrastination has wasted a lot of destinies, and majority of them do not know.

Doing the right thing at the right time is the cheapest way to save time.

Procrastination can be defined as put off doing things, leave things undone as long as possible. It will make you lack your real self.

Stop Procrastination, work things out and see changes in your life. A procrastinator will never be successful in anything, he will continue to waste his precious time.

## EXCUSE

Excuse still remains the enemy and the killer of time, and he who excels in excuses will never excel at anything else because he has already wasted the time he supposed to use in finishing things.

Excuse is the anchor that holds the ship to success at bay.

Friend, stop using excuse as escape route from your responsibilities. Always remember the atmosphere of excuses is the domain of mediocrity and the slay of time.

The slothful man saith, there is a lion in the way, a lion is in the streets.

**Proverbs 26:13**

## FUN

Fun! Oh! Fun! The slayer of potential giants, you reduce potential billionaires to paupers, reduce time to nothing.

The atmosphere of fun is the atmosphere of time killing. Fun stand for fall unknown next.

Fun is a time killer, sow now and reap something later or play now and reap nothing later. The choice is yours

## CHAPTER 10

## HOW TO SOLVE EVERY PROBLEM YOU MEET

Solving every problem you meet has really becomes difficult to mankind. Why is because man

has limit their self by not hearkening to good instruction.

My people are destroyed for lack of knowledge

My people are destroyed for lack of learning

My people are destroyed for lack of information

My people are destroyed for lack of insight

What a pain to humanity, what a tragedy to mankind because life is not how long you live but the positive impact you have contributed to mankind.

Today people are running from pillar to pole and pole to pillar why is because of problem.

Little thing has now become great burden to mankind all because of lack of knowledge.

**Welcome to the solution to solve problem**

1. Search the scripture
2. Ask the creator for way out
3. Think purely
4. Remove your mind from problem

5. Always be joyful.

## SEARCH THE SCRIPTURES

The scripture is a guide for living above every problem you can think of.

It is the manual for living a problem free life

The scripture are the words of the creator package in a book called the living bible, living without the scripture is living in darkness.

The labour of the foolish wearieth every one of them, because he knoweth not how to go to the

city.

### Eccl 10:15

For the commandment is a lamp, and the law is light, and reproofs of instruction are the way of life.

### Proverbs 6: 23

The scripture is one of the avenues through which your problem will solve.

The meek will he guide in judgment, and the meek will he teach his way.

**Psalms 25:9**

## ASK THE CREATOR FOR WAY OUT

In every problem you meet, there is always a solution to the problem in the hands of the creator.

The meek will he guide in judgment, and the meek will he teach his way.

**Psalm 25: 9**

Then shall ye return, and discern between the righteousness and the wicked, between him that

serveth God and him that serveth him not.
**Malachi 3:18**

But seek ye first the kingdom of God and his righteousness and all these things shall be added unto you. Matthew 6:33

Except the Lord build the house they labour in vain that built it, except the Lord keep the city, the watchman waketh but in vain.
**Psalms 127:1**

God's is the God of all solution, he said come unto me all ye that are labour and heavy hearted and I will give rest.

Jesus said to him "I am the way, the truth, and the life. No one comes to the father except through me.

## John 14:6

## THINK PURELY

Think straight and live straight. Think purely and see thing coming to you from above.

Blessed are the pure in heart, for they shall see God. **Matthew 5:8**

Friend, seeing God mean that the solution to that problem is in your hand. You can't see God and remain with those problem burden you.

When you see the hands of God, know that your life will always change for the better. But for you to see the hands of God, know that your thinking is pure. You can't be a negative thinker and see the hands of God, no way, God is pure.

## REMOVE YOUR MIND FROM PROBLEM

We are in a challenging world, and the world is looking for a challenger. You must pay the price in order to live above problem.

Remove your mind from problem and you will never see one, because as he think in his heart, so is he

Hard time must come but the ability to overcome it makes you a champion.

Champion is always made in the atmosphere of conflict.

Friend, look for solution to people problem, not causing problem in the society.

In everything give thanks, for this is the will of God in Christ Jesus concerning you.
**1 Thessalonians 5:18**

A mercy heart doeth good like a medicine: but a broken spirit drieth the bones.
### Proverbs 17:22

Joyfulness kills every form of weary and make the mind to think well. Friend, with joy shall you draw water from the well of salvation.

Whenever you are joyful, you always think straight and have straight result at ease.

Friend, the atmosphere where there is no joy, know that there can never be result there.

## CHAPTER 11

## THE WISDOM OF THE WISE

The fear of the Lord is the beginning of wisdom: a good understanding have all they that do his

commandments his praise endureth forever.
### Psalm 111:10

What man is he that feareth the Lord? Him shall he teach in the way that he shall choose. The secret of the Lord is with them that fear him and he will show them his covenant.

### Psalm 25: 12,14

Thou through they commandment hast made me wiser than my enemies: for they are ever with me.

**Psalm 199:98**

And unto men he said behold, the fear of the Lords that is wisdom and to depart from evil is understanding.

**Job 28:28**

And that from a child thou hast known the Holy scriptures, which are able to make thee wise unto salvation through faith which is in Christ Jesus.
**1Timothy 3:15**

The wisdom of the wise is a unique wisdom which is from above and make you ten times better than your course mate.

This wisdom of the wise is God in action, working toward people who know their God.

The wisdom of the wise is better and greater than anything. Happy is the man that findeth wisdom and the man that getteth understanding.

And pharaoh said into Joseph, for as much as God hath shewed thee all this is no one so discreet and wise as thou art.

Thou shalt be over my house, and according to thy word shall all my people be ruled: only in the throne will I be greater than you.

And Pharaoh said unto Joseph, see I have set thee over all the land of Egypt.

**Genesis 41:39-41**

Acting on God's word is wisdom and wisdom will overturn any mountain by the roots, no matter it's size. This wisdom is not ordinary, so the ordinary mind cannot comprehend it. It is with your spirit that you came in contact with this wisdom of the wise.

Wisdom is too high for a fool because his mind does not think straight but funny.

Wisdom is what determine your height on this earth, it is the master to fulfillment of destiny.

Wisdom is the principal thing, therefore get wisdom and with all thy getting get understanding.

This wisdom of the wise is not common sense, but scripture sense.

Through wisdom a house is built and by understanding it is established.

**Proverbs 24:3**

## CHAPTER 12

## THE POWER IN YOU

Be conscious that you are a unique being and you are made in the express image of God and his breath is in you.

And this is the record that God hath given to us eternal life, and this life is in his son. He that hath

the son hath life, and he that hath not the son of God hath not life.

**John 5:11-12**

The spirit of man is the candle of the Lord, searching all the inward parts of the belly.

**Proverbs 20:27**

I will praise thee, for I am fearfully and wonderfully made, marvelous are thy works, and that my soul knoweth right well.

**Psalm 139:14**

Friend, do you know you are so uniquely blessed? You are God's best, and there is so much that God has put with in you.

First, you are created in the express image of God, secondly, the spirit of God is in you only if you can understand it.

The spirit of the Lord shall rest upon him, the spirit of wisdom and understanding, the spirit of counsel and might, the spirit of knowledge and of the fear of the Lord.

**Isaiah 11:2**

I said, "You are gods, and all of you are called children of the most high. Psalm 82:6

But you are a chosen generation, a royal priesthood, a holy nation, his own special people, that you may proclaim the praise of him who called you out of darkness unto his marvelous light.

**1 Peter 2:9**

Friend, there is great power inside of you, only if you can sense it. God has given you power to dominate which other power you need.

God is the head of all power and your true power belong to God while belittle yourself.

A lion will always give birth to a lion not a dog. You need to rewire your mind set. You need to know the truth in order to be free.

Freedom only comes when you know the truth. Without the truth you remained in bondage.

Friend, God attribute is inside of you wake up and take your possession.

God has given you the power of exploit, to dominate and rule your world. What are you still waiting for?

Believe me or not, there is great power inside of you that can turn your world around

Ignorance have really eaten the heart of so many people. Some started worshipping stones, iron and even animal which God has given them for meat.

Walking without the right sense will make you to continue to see the wrony thing.

There is greatness inside of you but you need to discover who you are

## CHAPTER 13
## THE GOLDEN SECRET FOR LIVING

Living without a reason is the greatest tragedy in life. your life is not an accident, it is for purpose and when the purpose of a thing is not known abuse becomes the outcome of the day.

You need to understand the golden secret for living if you want to live a unique and pleasant life.

Everyone want the golden secret at their palm but doing it is always the problem of mankind.

The golden secret are the key secret to live a successful life. But secret are really important to destiny fulfillment.

The golden secret for living is a secret you can use to activate in any aspect of your life if properly apply.

## THE FOLLOWING ARE THE GOLDEN SECRET FOR LIVING.

1. Never eat the bread of idleness
2. Always look unto God
3. Place value on yourself

**NEVER EAT THE BREAD OF IDLENESS**
"No idle person is ever safe, whether he be rich or poor, white or black, educated or illiterate"

**Booker T. Washington**

"The desire of the slothful killeth him, for his hands refuse to labour. He covets greedily all the day long.

**Proverbs 21: 25**

Idleness is an enemy of destiny. It makes you "less than" instead of "more than" "Laziness goes so slowly that poverty overtake it" Dutch proverb.

Living a good life is all about working because the beauty of a man lies in his job.

"How beautiful is it for you to do nothing. And the rest afterwards.

**Alfred Femi Martins**

Prolonged idleness wears out creativity, go and look for job and picture your future to your taste.

"He who would really benefits mankind must reach them through his work" Henry Ford

Creative work gives savior to living, personal fulfillment is tied to personal achievement

Friend, the golden secret for living is work hard. Too much sleep makes your destiny slip. Wake up, your destiny is slipping away.

"Never be idle, but either be reading, or writing or meditating, or endeavoring something for the public good"

**Thomas Rempis**

See a man diligent in his business, he stand before kings and princess. Be wise

### ALWAYS LOOK UNTO GOD

There is a way that seemeth right unto a man, but the end thereof are the ways of death.

**Proverbs 14:12**

Always look unto God, not all that glitter is gold.

For my thoughts are not your thoughts, neither are your ways my ways, saith the Lord.

**Isaiah 55:8**

The chief golden secret for living is looking unto the creator, for the creator understand everything he created.

Man, even at his best mental state is still limited, every step you take can either take you forward or backward.

Walking in divine plan transforms an ordinary person into an extraordinary one

The cheapest way out of frustration is to abide in God's plan for your life.

Friend, for your future to come into land mark, you need to discover who you are and why you are been created and follow the creator plans for your life.

Knowing your assignment determines your attainment in life

The labour of the foolish wearieth every one of them because he knoweth not how to go to the city.
**Ecclesiastes 10:15**

Hear instruction, and he wise and refuse it not.
**Proverbs 8: 33**

## PLACE VALUE ON YOURSELF

Value is the key secret for living a golden life. It is the juice for responsibility and becomes responsible your life is for a reason and for a season. Don't live your season without your reason.

"The greatest tragedy in life is not death, but life without a reason, it is dangerous to be alive and not know why you were given life.
**Myles Munroe**

You can't live your life anyhow, and expect to live like the wise. He who disvalue his life will see himself in the congregation of the death.

Living without value is living without meaning your focus is a picture of what you eventually possess.

Behind every successful enterprise is a courageous decision of value. never live for today but live for tomorrow.

Friend, placed value on yourself, package yourself to the taste you want to live and have the golden secret for living at your hand.

Never belittle yourself, no matter the condition at that moment. Changes must come to you always have the mind-set of the wise.

# CHAPTER 14

## TAKE ACTION NOW

Don't make noise, make move, the train is still moving you can still catch up with it.

Your life is for a reason and for a season, use your season now with a reason. Because devalue will still become the order of the day.

"Your assignment is not your decision. It is your discovery.

**Mike Murdock**

You have known the truth, why wait, run with it in order to be free.

"The greatest tragedy in life is not death, but life without a reason, it is dangerous to be alive and not know why you were given life"
**Myles Munroe**

Break your own record now, tomorrow may be too late. Improvement still remain the larges room on earth.

To rest is to give room to the spirit of failure. Commit yourself now because you are launching yourself to distinction.

Decide now to be the best and walk toward it, because everyone in your life is a passenger. You are the driver of your destiny, where you turn the steering becomes your direction.

It is not too late, it is only too late when the head is cut-off. There is a power within you to change your destiny.

Make decision now and change your story **in life.**

"Courage is the standing army of the soul which keeps it from conquest, pillage and slavery".
## Henry Van Dyke

"Ninety-nine percent of failure come from people who have the habit of making excuses. George Washington.

"It is at your moment of decision that your destiny is shaped.
## Anthony Robbins

Whatever you focus your attention upon, you give strength and momentum to"

**John Mason**

"You are the way you are because that's the way you want to be. If you really wanted to be any different you would be in the process of changing right now"

**Fred Smith**

Break your barriers and blossom, there is no time to waste any more. The secret of great men lies in their decision.

Move ahead with expectation. "Expectation is the mother of Manifestation"

**Dr. David Oyedepo**

"Without action vision is impotent. Men of action rule the world".

**Alfred Femi Martins**

## CHAPTER 15

## THE WISE SAYING

- Never live for today, live for tomorrow
- A true champion is one who fight for his country
- Walking in the congregation of a fool is as walking in the congregation of the death
- Wisdom is not all about age but having the Holy Spirit in you.
- Life is not how long you live but the impact you make

- Living without value is existing without meaning
- He that walk with the wise will increase in knowledge
- Leadership is not all about power but all about serving the interest of your people.
- Anything that has wasted your time has wasted your life
- There is no secret ingredient in life, the only secret ingredient is your believe
- Knowledge is power but wisdom rule the world

- Never settle for half bread, go for full bread
- Don't make noise, make move
- Ignorant still remain the greatest killer disease
- Maturity is not all about age but the ability to comp yourself makes you mature
- Never look for power, power is inside of you
- Use your brain not your head.
- Protect what you value or it will soon disvalue
- Looking unto Jesus, he is the all in all
- Good name is the best legacy to live
- Never turn back on the creator

- Excuses still remained the robber of time
- Picture what you want to be and walk toward it.
- Guide your mind for weeds not to grow inside
- There is no problem, everyman problem is his ignorance
- Think before you talk, word are spirit
- Great learners are great potential leaders of tomorrow
- Friend, your tomorrow start today.
- Men on mission without vision will always end in division

- Never allow your emotion to determine your direction
- Evil communication corrupt good manners
- Never remained at the ground when you fall, bounce back again.
- Your strength lies in your inside
- The beauty of a woman lies in her character
- The beauty of a man lies in his job
- Think straight and live straight
- Be good and see good

- Your best friend is the one to bring the best in you
- Never fight the fight you will not win
- Winner are not born but are made
- Walking in the shadow of death mean walking in the grave
- Always think before you act
- A true leader never fight for power but power is given to him
- What you sow, you reap

- Eyes will first eat before the mouth, use your brain
- Never you give your strength to a woman
- He who lies in Delilah lap will never return alive

## REFERENCE

- The Holy bible (King James version and the new international version)
- Pillars of Destiny (Dr. David Oyedepo)

- Being the Best (Alfred Femi Martins)
- The Power of your mind (Chris Oyakhilome)
- The visionary youth (Poto Stephen)
- Understanding Divine Direction (Dr. David Oyedepo)
- Towards mental Exploits (Dr. David Oyedepo)
- Goals (Brian Tracy)

www.ingramcontent.com/pod-product-compliance
Lightning Source LLC
Chambersburg PA
CBHW072140170526
45158CB00004BA/1450